100 Secrets
of the Art World

D0377931

Thomas
Girst

Magnus
Resch

A Note ————————————

In Edgar Allan Poe's »The Purloined Letter« of 1845, the Parisian police repeatedly raid an apartment in search of a stolen letter whose secret content could bring about the downfall of a minister. Despite employing microscopes and seeking everywhere, they don't find anything. What they are looking for eventually turns out to have been placed right in front of their eyes: in a card rack dangling from a knob beneath the middle of the mantelpiece. Hidden in plain sight – on purpose, so as not to be found. With »100 Secrets of the Art World« we thought that instead of doing the rummaging ourselves, we'd ask those in the know to shed some light on what is happening at the very centre of the art world, yet remains unbeknownst to most and is rarely discussed. Knowledge is power and knowledge is often classified. Competition, too, breeds secrecy, among art historians and art dealers alike. And though much of the art market itself may be driven by status anxiety, gossip, and rumour, its currency is confidentiality and discretion is strongly advised.

It was four decades after Poe's story that dozens of secret letters by Romantic poet John Keats to Fanny Brawne, the love of his short life, were sold in London by Sotheby's on March 2, 1885. In his poem »On the sale by auction of Keats' love letters,« Oscar Wilde chastises »the brawlers of the auction mart« who »bargain and bid for each poor blotted note«: »I think they love not art / Who break the crystal of a poet's heart.« The secret was out, however, and a book of the letters sold exceedingly well in the late nineteenth century. Certainly, a secret revealed is no longer a secret. Yet as the contributions for

to our Readers

»100 Secrets« started coming in – a surprising number of which echo Wilde's sentiment – every one of them confirmed the validity of our quest to offer insights from all sides as to what constitutes the art world today. Their random order allows for serendipity. So yes, we ended up with an eclectic little book, fierce and full of idiosyncrasies. Its pages may provide guidance, how-to, and self-help advice. There are playful entries and there are transformative entries, there's humour and there's sincerity, absent all irony or sarcasm. Above everything, »100 Secrets« is an honest survey of contemporary art and its protagonists.

We wish to wholeheartedly thank the many contributors to »100 Secrets,« many of whom provided unique designs together with their original entries. Your generosity and shared insights are the very essence of this book! Thanks as well to Studio Umlaut, Munich, for the design and concept of »100 Secrets.« It is their vision which turned the book into such a visually alluring read. We are grateful to Franz Koenig and Anastasiya Siro. Courtney Plummer's assistance was equally of help.

»In nature's infinite book of secrecy, a little I can read,« proclaims Shakespeare's soothsayer. We hope that with »100 Secrets« we will be able to provide the inclined reader with a similar glimpse into the intricacies of the art world.

Thomas Girst Magnus Resch

100 Secrets by

<u>Daniel Birnbaum</u>
**Director of Moderna Museet,
Stockholm**

THE BEST
KEPT SECRET
IS THIS:

Gregor Muir
Executive director, Institute of Contemporary Arts, London

I have a secret, which is not really my secret, although I've been holding on to it ever since it was relayed to me by a famous artist. The secret goes like this. One day the artist, who was much younger at the time, picked up a call from a collector who had acquired one of his early paintings on the secondary market. Having kept the work in storage ever since, the collector only recently discovered that there was a small area of cracked paint in a corner of the canvas, which didn't look so good. Before returning the painting to storage, the collector thought he would contact the artist and ask him whether, for a modest fee, he would repair the damage. The artist said yes.

A few days later, the painting arrived at the artist's studio. Still in its wooden packing crate, the art handlers heaved the large-format painting up against a wall and removed the front panel so the painting faced outwards and could be worked on. Looking at the painting, the artist realized two things. First of all, he didn't like the work any more – it wasn't how he remembered it. Secondly, in order to repair the damage, the artist decided he might as well rework the entire surface and blend in any cracks, making them less visible. Over the course of the day, he applied layer after layer of fresh paint, turning a monochromatic abstract work into a representative image of a cow in a field, not even a good one.

The next day, the art handlers returned to the artist's studio, closed the crate back up again, and the painting – now completely different – was carted off to storage. Years have since passed and the artist has yet to hear from the collector.

Ólafur Elíasson
Danish-Icelandic artist, Berlin

In reality
art welcomes you
In reality
art generates trust
like nothing else
In reality
art is an ideal mediator
of conflicts
In reality
art makes the
best parliament
In reality
art creates the
strongest public space

In reality,
to experience art
is to inhale
and exhale society
In reality
art invites you to
explore yourself,
perceptions, dreams,
social relations,
the world, and
everything that hasn't
vanished into a
black hole yet
In reality art is real

Philip Tinari
Director of the Ullens Center for Contemporary Art, Beijing

If you don't have a VIP card, you can usually register for a press credential. Especially for ardent would-be critics and curators just starting out, this trick can save you money and might even motivate you to write down and publish your thoughts on whichever art fair, biennial, or exhibition you happen to attend. It's an interesting paradox – the way the art world needs to manufacture on-site exclusivity even as it strives for in-print and online visibility. Members of the media – which includes more and more of us as new platforms continue to lower the threshold for one-to-many transmission – are automatically granted a front-row seat. And, in the end, it's what keeps this whole ecology of exhibition-driven wayfaring alive in the era of digital reproduction – that fundamental, and justified, belief in the idea that one needs to see the thing, or experience the space, in person.

John Baldessari
Conceptual artist, Los Angeles

nobody knows I don't know how to draw.

Georgina Adam
Art market columnist for the Financial Times
and the BBC

There is no Dr No hiding stolen art. Literature and particularly film sometimes feature shady Mr Bigs, whose (generally underground) lairs are full of filched masterpieces, prizes they gloat over in secret. James Bond famously spotted

Goya's Portrait of the Duke of Wellington in the film Dr No, in the villain's Crab Key base. The painting had genuinely been lifted from London's National Gallery by a sixty-year-old amateur thief just before filming had begun. But in real life, according to specialist policemen, masterpieces are stolen for use in drug and other illicit deals as collateral, and the »Mr Big« story is just that... fiction, not fact.

Josh Baer
**Art adviser and founder
of The Bear Faxt**

My brain retains faces, numbers, logins, passwords, but not visual images. Odd?

Bose Krishnamachari
Artist and president of the
Kochi Biennial Foundation, Mumbai

Nothing will be conceptually or visually interesting

If there are no oppositions,

If there are no contradictions,

If there are no parallels,

If there are no extremities

I believe that everything co-exists in this world but

I would like to keep or see

polarity / ambivalence / opposition /

contradictions / parallels / extremities next

to each other / facing each other

Femininity and masculinity

Are either rims of the spectrum

Making it complete

Together, face to face, they can twist it

Give it new meaning

And discover new colours and contours

Like

Juxtaposed extremities

Matthew Slotover
Co-publisher of Frieze and co-founder
of Frieze Art Fairs

And in the end,
the love you take
is equal to
the love you make.
You may
recognize it
as the last line
from the
last Beatles song.

Alexander Zacke
CEO of the global online auction house Auctionata

When I was in my early teens, I fell in love with a nice little Goya oil showing some salmon steaks on a dark background. Goya seems to have liked the subject, as he had done it several times, with other sorts of fish and with meat. Most of them seem to be unsigned and therefore are – unless you are an expert in old masters – quite hard to spot. Over the years, it became my obsession to look at paintings and works of art in museums and to always ask myself the question: would I be able to identify this at a garage sale? I played the game with Cezanne's lemons, some earlier pastels by Degas, Qianlong's calligraphy, the Gutenberg bible, Charlemagne's chess set... Over time, the game helped me to better understand the reasoning behind some artworks, their logic, the skills applied, and, most important, the state of mind of their creator. In an ensconced way, art can be the expression of an often eccentric, offbeat, enlightened, precious state of mind. Some artists loved nothing more than to hide the weaknesses of their mind as its strengths. If done well, it's almost impossible to see, but it's in every piece by the artist – it can never be completely hidden. Over the past decades, the almost invisible »precious state of mind« became a guiding hand for me, a little bit like »the Force« or »la grande main«, when I was strolling around auction previews, flea markets, pawn shops, antique malls, and garage sales. After thirty years in the trade, it left me with the simple understanding that the philosopher's stone is always to be found despised and buried in the mud.

Klaus Biesenbach
Director of MoMA PS1 and chief curator at large, Museum of Modern Art, New York

One of the best-kept secrets is whenever a curator enters a new museum or gallery where he is doing his first show or installing a traveling show, the most important thing to do is to sit on the floor in a corner of the most challenging, if not the biggest, of the galleries.

Thus you place yourself as an object in a corner with direct connection to the floor and two walls. It is so easy to not remind yourself that art is an object in space; that you are an object in space. Doing this, immediately you cannot avoid the dimension of time, which of course you and the object share. It's an exercise I always do and sometimes colleagues in the museum are surprised. It's an exercise as simple as looking down at your body, at your feet, and seeing where you are standing, here and now.

Olaf Nicolai
Conceptual multimedia artist, Berlin

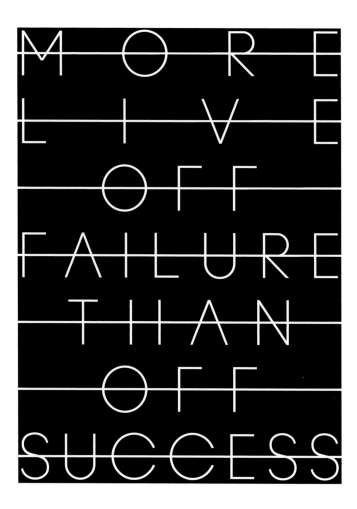

Carter Cleveland
Founder and CEO of Artsy, New York

The biggest kept secret is ironically something Joseph Beuys said in plain sight: »Everyone is an artist.«

Sylvain Lévy
Collector and co-founder of
the DSL Collection, Shanghai/Paris

My personal best-kept secret is simply art as an Art de Vivre. Stop fetishizing artworks. Move beyond possessing to being. Turn art into a real and singular experience by approaching it through anecdotes.

Bisi Silva
Director and curator, Centre for Contemporary Art, Lagos, Nigeria

Demas Nwoko, the Nigerian painter, sculptor, designer, creative architect, writer, publisher, and stagedesigner, was a founding member of the student art association that became known as the »Zaria Rebels« in the 1960s at the Ahmadu Bello University, Zaria. In conjunction with colleagues such as Yusuf Grillo, Bruce Onobrakpeya, and Uche Okeke, they challenged a colonial art education in which their cultural heritage and histories were denied. In so doing, they created works which were a natural synthesis of Africa and Europe, ushering in a pivotal moment in the history of Nigerian art which, in his ground-breaking eponymous publication of 2015 on the subject, art historian Chika Okeke-Agulu called »Postcolonial modernism.«

Through his art, and especially his design and architecture, Nwoko sought to imbue his African heritage with his modern reality. His first major architecture project, the Dominican Mission in Ibadan, is one of the most successful symbioses of African design and Western architecture, resulting in its inclusion in the publication »1001 buildings you must see before you die« by Mark Irving.

An important and understudied artist, Demas Nwoko is the quintessential postcolonial artist.

Sarah Thornton
Canadian cultural writer and sociologist,
San Francisco

THE CHIEF CURRENCY OF THE ART WORLD IS NOT DOLLARS, POUNDS,

SWISS FRANCS, OR CHINESE YUAN. IT IS AN EXCLUSIVE AND OFTEN CONTESTED VALUE — CREDIBILITY.

Louise Blouin
CEO of Louise Blouin Media

Art Without Borders ———— Art is a place without borders. It is like looking at the horizon or gazing at the heavens; it is a space that is infinite. Art has the power to disorient; like being in a cloud, or caught in an avalanche, not distinguishing up from down. With its same power to disorient, art also has the power to liberate. Art breaks down borders and overcomes restrictions with the goal of stimulating both unconscious processes and conscious thoughts. **Art creates new gestures, concepts, sensations.** Out of the disorder, clarity is found. Art engages my imagination and my dreams. From the paintbrush to the notes on a page, to a taste or touch or smell. When these senses are activated, creating a new and profound composition, I am transported – nothing

can be more incredible than when my imagination is fed by something as meaningful as art. When we decipher the forms through color, shape, sound, a new world is revealed, one that even the artist does not anticipate. These dots, lines, strokes lead beyond the canvas, the page, the concert hall, into the unknown where again your best friend is the imagination. **An important instruction:** let children imagine more, and do not kill their dreams with restrictive tasks and repetitive thoughts. I am alive through my imagination and I work each day with my heart and soul to share this experience; the experience of innovation, of creativity, of art. **Dream with all of us, and thank you to those that help us dream through their art.** ———

Victoria Siddall
Director of Frieze and Frieze Masters Art Fairs, London and New York

Artists are the best teachers. Visit a museum with an artist and you will get a totally new perspective on works that you thought were familiar. Artists learn from other artists' work, regardless of when it was made, and hearing them speak about it makes hundreds of years melt away and old masters become immediate and current. Walking around the National Gallery with Cecily Brown beat all of the art history lessons I had at school.

Stefan Simchowitz
South African LA-based filmmaker, art collector, curator, and adviser

The intention of the artist has little to do with the outcome of the artwork. The intention of the collector has little to do with the quality of the artwork. The intention of the institution has little to do with the value of the artwork. The intention of the dealer has little to do with the success of the artist. Intentions are the hazardous zone of any business, especially the art world, and the moral quagmire of intention, idea, virtue, value, quality, authorship, and outcome binds the art world into a constant mess of muscular distress. It is best to keep one's intentions simple and limited to the most basic of human needs – like I intend to only wipe my ass with flushable baby wipes and to avoid at all cost one ply toilet paper which in my belief is one of the banes of contemporary life: public bathrooms and galleries that are too cheap to spring for the two ply.

Patrick Kelly
Managing director Cultureshock Media and former publisher of Art Review

Real Power
The best-kept secret
of the art world is
that real power is
valet parking.

Secret Ingredient
As Calvin Tomkins says,
since Duchamp anything
can become art but
that also implies the con-
verse, that nothing can
come of art. The question
then is what makes art
become something.

Faking It
I've not been to Miami in several years after eight
consecutive fairs, but if anyone asks, »didn't I
see you in Miami?«, or anywhere else on the circuit
for that matter, that answer is always, »absolutely,
yes, great to see you again.« My hope is to even-
tually cut out all travel and maintain the same level
of presence around the world.

Benjamin Genocchio
Director of The Armory Show, New York

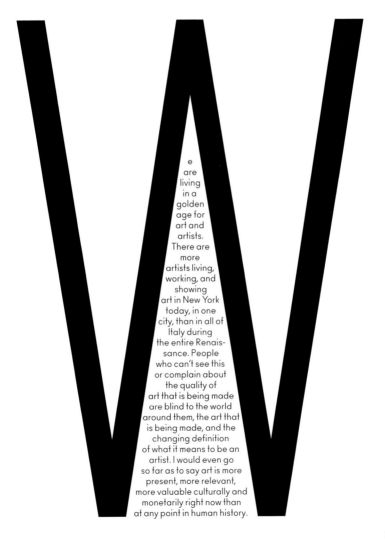

We are living in a golden age for art and artists. There are more artists living, working, and showing art in New York today, in one city, than in all of Italy during the entire Renaissance. People who can't see this or complain about the quality of art that is being made are blind to the world around them, the art that is being made, and the changing definition of what it means to be an artist. I would even go so far as to say art is more present, more relevant, more valuable culturally and monetarily right now than at any point in human history.

Marina Abramović
Performance artist and founder of the Marina Abramovivić Institute

when you say no to me, it's just the beginning

Natasha Degen
Author and faculty member,
Sotheby's Institute of Art, London, New York,
and Los Angeles

—— In general, art is intrinsically pretty worthless (canvas and paint don't cost much); the art world endows it with value. It must be contextualized (in essays by critics and historians, published in glossy catalogues), lavishly presented (in well-located white cubes), and widely circulated (in exhibitions near and far). These art world norms are expensive, so businesses are often buttressed by wealth derived from other sources – inheritances, real estate holdings, and, in at least one instance, arms dealing... ——

Anthony Haden-Guest
British American columnist, cartoonist, and art critic

Talent

A basic talent for making art is NOT necessarily the top requirement for having a successful art career, by which I don't mean making money but making work. At any decent art school graduate show, you'll see work as well-made as you will see in galleries. But few of those graduates will become artists. A need to unload, a strategic intelligence, and raw will are also crucial. Without them, skills, even dazzling skills – what Robert Irwin dismissively called his »magic wrist« – are kind of like tap-dancing. Indeed, they can, in our Po-Mo culture, be a burden.

Private Views

Core art worlders never look at art during private views. They have seen it, and they are there to siphon information from other core members, the Ear being the most important art world organ, not the Eye. The people actually looking at the art are essential but unimportant, like movie extras in a battle scene.

William Lim
Award-winning Hong Kong architect and art collector

I get asked often where to find Hong Kong artists' works. I do not want to share this, but check out the annual ParaSite charity art auction. The days of bargain hunts are gone, but you can still find great donated works by Hong Kong artists, some of whom may not even be represented by galleries yet. I bought one of the most interesting works in my collection there, One Day of the Artist's Life by Pak Sheung Chuen, with no other bidders.

Massimo De Carlo
Italian gallerist with spaces in Milan,
London, and Hong Kong

ACADEMIC OR SOCIAL, ELITIST
OR POP: THE CULTURAL CHANGES OF
SOCIETY CAN NEVER FULLY
DESCRIBE WHAT ART IS ABOUT. ARTISTS'
SECRETS CAN ONLY REMAIN SECRET.

Holger Liebs
Art critic and former editor-in-chief of Monopol magazine

THE BIGGEST SECRET IN THE ART WORLD IS THAT NO ONE KNOWS WHAT'S CONTEMPORARY ART!

Pari Ehsan
Architect, interior designer, blogger

In a society flooded with information and imagery, what creates a lasting impression? I've always been drawn to the odd, weird things and people. They draw us out of our head and into the moment, and at the highest level cause one to question unconscious thought patterns. I try to create a moment of something »off« in every image; I've also found this the only way to find peace in my perfectionism.

<u>Udo Kittelmann</u>
Director of the Nationalgalerie, Berlin

Towards the twenty art – as to we still know reach its because it its

the end of
first century,
some extent
it today – will
limits,
keeps losing
magic!

Maike Cruse
Director of Art Berlin Contemporary
and Gallery Weekend Berlin

It
is
not
necessarily
always
the
gallerists
that
need
to
treat
everyone
else.

Adrian Cheng
**Hong Kong collector and director
of K11 Art Foundation**

YOU CAN NOW FIND ALL THE ART WORLD'S SECRETS ON INSTAGRAM ENCODED IN HASHTAGS.

Dakis Joannou
Art collector, industrialist, and founder of the DESTE Foundation for Contemporary Art

"Nonsense! Everybody knows that the sun revolves around Dakis Joannou."

Pablo Helguera, drawing from the series Artoons, 2009. Courtesy of the artist.

Marta Gnyp
Dutch art adviser, journalist, and collector
based in Berlin

Don't believe in the categories of good and bad collectors. Whatever reason brings people into the art world, it is for a good reason.

Art has a wonderful capacity for surviving everything, including speculators, snobs, and true aesthetes.

<u>Kelly Ying</u>
Collector and co-founder
of ART021, Shanghai

Never ask
for a discount. It seems
to be common practice, but
don't push too much for one. You
risk losing the artwork, or the owner
will never give you better works
since he knows you are a »discount«
person. Art is not a commodity or
a product. Stop the bargaining
in the art world – in Asia
and elsewhere.

Can Elgiz
Collector and founder of the Elgiz
Museum of Contemporary Art, Istanbul

As a collector, everybody always asked me: »How did you begin to collect and why are you collecting?« Very recently, I found out that my great-grandfather was also an art collector, and now I know that this interest is ancestral. My great-grandfather Halim Bey was an art collector in the nineteenth century when he was living in Lesvos/Mytilene Island, Greece. The house, today known as Halim Bey House, which my forefather used to live in before he had to leave the island for Turkey, has been used for exhibitions and is now run by Lesvos Municipality.

I heard that the day when A showed his Y performance piece for the very first time in NYC in the "Angry colour" show, G, who had just opened FIST, mentioned to K that if Y –

despite its immaterial nature – wouldn't sell in Basel in 10 minutes he would eat L's balls. It turned out that A at the time had an affair with G's wife J who wrote for – you know... – and when he dumped her the review she wrote about Y was as negative as it could be. G got very angry with J about the article, but being the main coke provider of A, he also saw a profound depression growing on A's horizon which meant a promising future side income to him so he invited A to a weekend on Fire Island with two Russian escorts pretending to be there for him in those difficult days. But A smelled a rat and – after mixing the entire extra portion of coke that G generously had given him as a welcome gift into his host's Pina Colada – A fucked both escorts and left to meet with L. At the time L who, after his epoch-making show "Odd Art from Kazakhstan", had just opened his show on "New Ecstatic Melancholism", was about to sell his Napa Valley vineyard in order to finance his real estate project in Zumikon. The only person who could stop him from doing that was G, who had successfully slept a few times with the accountable town official in Zumikon (he called her Willendorf, she didn't get it) to reserve the same piece of land for his "Post-Post-Sculpture" project. When L heard from A about G's ridiculously predictable weekend invitation they forged out a funny plan: they would mold L's anus, enlarge it and cast of it a shiny aluminum sculpture pretending that the aluminum was from recycled Fukushima waste. The plan was to place the piece at night in front of FIST and publish an anonymous press call the next morning stating that FIST was contaminated. J, who had overcome her anger about A and even felt kind of guilty about her review, called him incidentally that very night. The still offended A couldn't resist and recklessly told her the whole story. J couldn't help but laugh about G's unscrupulousness. At the same time she was revengeful and wanted nothing more than to damage her husband's career. So the next morning after her Pilates with your Pilates class she called him for the code of his sex toy safe pretending she had a lonely afternoon and the

Loic Gouzer
Deputy Chairman, Post-War and
Contemporary, Christie's

The most underrated role in an auction house is the role of the art handler. For me as an auction house specialist, the only way to know if you did a good deal is to ask the art handlers. They can predict if a work is going to sell or not. Art handlers don't say much, but they know it all. It's also they who get to experience art in its sexiest condition. There is simply no better place to see art than the neon glowing corridor of a Bronx storage facility where art is still half crated. It looks so much better than on any museum or gallery wall in the world.

JR
Activist, photographer, street and graffiti artist

I HAVE NEVER STUDIED PHOTOGRAPHY OR HOW TO USE A CAMERA. IT TOOK ME YEARS TO TECHNICALLY UNDERSTAND HOW F-STOP/APERTURE, SHUTTER-SPEED, AND DEPTH-OF-FIELD ALL WORK TOGETHER, BECAUSE I WAS AFRAID TO ASK ANYONE TO TEACH ME.

Anna Somers Cocks
**Founder of The Art Newspaper and CEO
of Umberto Allemandi Publishing**

Venice has less than one hundred years
to go if current predictions of
sea-level rise are right. The Consorzio
Venezia Nuova, the group of
businesses building the barriers between
the Adriatic and the lagoon, have
prevented the Unesco reports on predicted
water levels from getting publicity
because they want people to believe
that they have provided the final solution.
The truth is that the barriers
are effective as temporary obstacles
to flooding, but cannot stop the chronic
rise in the water level except
by being permanently closed, which is
ecologically unviable.

Esther Mahlangu
South African Ndebele artist

My
whole life
I have strived
to show my work to people from all over the world
and tell them my story as an artist, a Ndebele artist, a
woman Ndebele artist – and against all odds, today
my work is in many museum collections and that makes
me happy, as I know
long after I am not
here anymore, peo-
ple will still go and see the paintings and they will
remember there was an artist called Esther Mahlangu.
Young Ndebele people may not know where life will
take them, but ART roots them to their Ndebele culture.
ART is in my heart
and it's in my
blood.

Nicolas Berggruen
Billionaire collector, philanthropist, and investor

Experience and buy art with your eyes.

Juan Gaitán
Director of the Museo Tamayo Arte Contemporáneo, Mexico City

BUT IN THE ART WORLD THERE ARE NO SECRETS! YET, WE SEEK THE SECRETS OUT BECAUSE KNOWING THEM SEEMS IMPORTANT, AS THEY GIVE US WHAT TO TALK ABOUT, AND THEY MAKE US FEEL IMPORTANT, INCLUDED. SO I DO HAVE SOMETHING TO SHARE, WHICH I URGE THE READER TO READ AS IF IT WERE THE WEATHER CHANNEL: PRICES ARE ON A HIGH, SALARIES ON A LOW. ART IS NOT FOR THE POOR. THERE IS MARKET SPECULATION, AND THERE IS WHAT WE SPECULATE ABOUT THOSE SPECULATIONS WHEN WE GO TO THE MARKET, A META-SPECULATION THAT WE THRIVE ON, ESPECIALLY AFTER A FEW BOTTLES OF WINE. WE LOVE ART, BUT WE DON'T KNOW EXACTLY WHERE THIS LOVE IS COMING FROM. WE CAN'T SAY WHY ART SHOULD CONTINUE TO EXIST, BUT IT SHOULD, FOR IT MAY STILL IMPROVE OUR POLITICAL IMAGINATION.

Stefan Sagmeister

Austrian graphic designer and co-founder of
Sagmeister & Walsh Inc., New York

If the laws of the
applied
everybody would
the collectors, the
the
the
and the top
the

financial world
to the art world,
be in prison:
gallerists,
artists, the critics,
museum directors,
people who run
auction houses.

In the radical future, I don't think art advisers or galleries will be necessary. They won't disappear, but the way they conduct business will alter drastically. Artists will hold all of the cards and technology will provide the tools that collectors need to make the right decisions.

Len Blavatnik
Russian-born businessman, investor, and philanthropist

When asked about
their collection, many collectors
neglect to say that
they have a favorite piece.
I have one favorite piece among
the many that I own.
It's a portrait of
Albert Einstein from Warhol's
1980 series of paintings,
Ten Portraits of Jews of the
Twentieth Century.
It combines two individuals I have
always admired:
Albert Einstein and
Andy Warhol.

Sam Bardaouil and Till Fellrath
Co-founders of Art Reoriented,
Munich and New York

»In this hour, when the entire world cares for nothing but the sound of cannons, we have found it our duty to provide a certain artistic current with the opportunity to express its freedom and its vitality.« – Opening statement from the catalogue of Art et Liberté's first exhibition of independent art, February 8-24, 1940.

Our art world secret is Art et Liberté, a political artist and writer collective based in Cairo broadly from the late 1930s until the late 1940s. Notable figures include Georges Henein, Ramses Younan, Fouad Kamel, Kamel-el-telmissany, Ida Kar, Inji Efflatoun, Amy Nimr, Edmond Jabes and Albert Cossery.

With the 1938 publication of their manifesto Long Live Degenerate Art, Art et Liberté sought to disrupt their cultural and political milieu and, in their negotiation of Surrealism, to create a contemporary literary and pictorial language at once globally engaged and rooted in local artistic and political concerns. Through their bulletin, named after the group, and through periodicals, self-published prose and poetry, and the numerous exhibitions of independent art that they mounted, Art et Liberté provided a generation of disillusioned Cairo-based artists and writers, Egyptian and non-Egyptian, women as well as men, with a heterogeneous platform for cultural and political reform.

Rebels in the face of oppressive colonialism, Art et Liberté also stood throughout the Second World War against the alignment of art and political propaganda, rejecting the creeping fascism that had been posing a threat in Egypt since the early 1930s. The movement also rejected both the academicism imported by the state and the conservative bourgeois morality that celebrated »art for art's sake.« Their connections across an artistic and literary network spanning Cairo, Beirut, Athens, Paris, London, New York, San Francisco, Fort-de-France, Mexico City, Santiago de Chile, and Tokyo, to name but a few, challenge the regionalist approach to the study of modernity.

By the end of the 1940s, several of the group's members were in prison or in exile, George Henein had written to André Breton formally withdrawing from the Surrealist movement, and the movement went into decline. Their brief passage on the Egyptian modern art scene, however, had a significant impact on a younger generation of artists and writers destined to become leading figures in Egyptian modernism over the decades that followed.

Adam Lindemann
Art collector, private investor,
writer, and dealer

We all know the tune

»what goes up,« »must come down«,

but remember this –
in the art market, the exception
is the rule.

Christoph Niemann
Illustrator and artist, New York
and Berlin

If you want to
break an
artist's heart, pay
him / her
a compliment
that starts with
»Your work
reminds me of…«

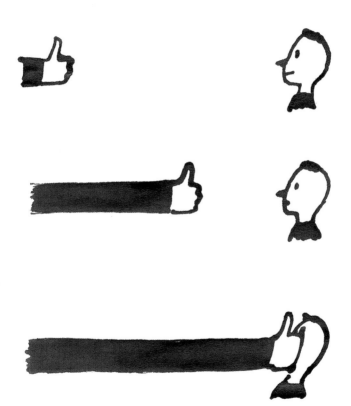

Prateek and Priyanka Raja
Directors of Experimenter, Kolkata

FOR GENERATIONS, Kolkata, in the eastern part of India, has been the seat of cultural debate, political ideologies, revolutionary movements, and progressive social change. For thirty-four years, it has also been home to the longest standing democratically elected communist government in the world. The average visitor to Experimenter is therefore extremely well versed in literature and politics, quotes philosophy and theoretical mathematics in the same breath, and can speak about art, both visual and performing. It is therefore not unusual for complete strangers to engage in argument and debate in the gallery.

In the early years of the gallery, we walked in on a weekday morning to find two visitors – unknown either to each other or to us – in animated and combative discussion about a video we were exhibiting. After a loud fifteen-minute argument on what the video was about – by which time they must have watched it at least ten

times – one person left in a huff. The other stayed on to see the video again. Barely even looking in our direction as we approached, he nonchalantly requested a cup of tea since he wanted to spend more time watching the video. We, of course, quietly obeyed. The man watched the video in silence, sipping his tea… maybe stayed back for a couple more repeats of the video, and then left. Later that evening, opening the guest register for comments, I saw that the man who had remained had written a one-thousand word essay on the video, laying down his observations, clearly and systematically cross referencing from other practitioners, and also recording the views of the other person!

This is the joy of running Experimenter in a city like Kolkata. Fraught with opposing voices and differing opinions, and uninhibited by the idea of the white space, the viewers engage in the program at the gallery like nowhere else in the world. It becomes a topical melting point of conversation and thought, extending well beyond the physical space of the program.

<u>Simon de Pury</u>
Auctioneer, former co-founder of Phillips de Pury

Having an

(preferably a good one) and knowing how to keep a secret.
There is a certain justice in the art market that those who buy with their

eventually fall flat on their nose
while those who buy with their

eventually get rewarded.
In an art world that thrives on gossip, being able
to keep a secret clearly sets you apart.

Don Thompson
Economist and author on the
Art World, Toronto

Art collectors with access to VIP lounges at Art Basel fairs in Basel, Miami, or Hong Kong might wonder why the Luxembourg Freeport or The Singapore Freeport are major fair sponsors. Each has an elaborate booth alongside more obvious sponsors UBS (Union Bank of Switzerland), BMW, and Ruinart champagne. Observers might also wonder what becomes of so much of the high-priced art sold at fairs or evening auctions. Often, no publication reports its destination or identifies the purchaser. The answers to those questions might just be related.

Philippe Pirotte
President of Städelschule,
Frankfurt

SECRETS ARE AS
OXYGEN TO ART.

OR AS A CHINESE
PROVERB SAYS:

IN TOO TRANSPARENT
WATER THERE ARE
NO FISH.

Kate Bryan
Presenter of The Art Show and former
director of Art16 and the Fine Arts Society

Art has been my passion my whole life and I couldn't wait to get into the art world to meet like-minded souls.

The thing that continually surprises me is how many people in this industry know nothing about art. Worse still, they don't seem to even care for the art.

I could even go as far as to name some of the guilty parties right in this book, as they would never pick up a book about art anyway.

What are they doing here?

<u>Dan Perjovschi</u>
Romanian artist, writer, and cartoonist

I AM
NEOLI
POSTM
EXCOM

José Kuri
Co-founder of Kurimanzutto Gallery, Mexico City

Very few people know of Isamu Noguchi's undiscovered mural in Mercado Abelardo Rodriguez, the first modern market built in Mexico City in 1934. The story surrounding its conception is that Noguchi was once Brancusi's assistant. Upon Brancusi's suggestion, Diego Rivera met the young Japanese-Californian and commissioned him to create a mural. The unexpected surprise surrounding this mural (constructed in 1935-36, during the time that Frida Kahlo took an intimate liking to Noguchi), is not only its figurative social realism, but also its volumetric concrete form, so completely unlike Noguchi's later work for which he became famous.

<u>Gabriele Horn</u>
Director of the Berlin Biennial for Contemporary Art

To me, the secret of success for any biennial relies on the ability

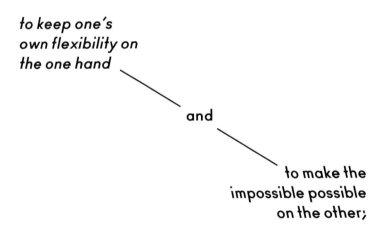

to keep one's own flexibility on the one hand

and

to make the impossible possible on the other;

this is where fun and creativity from all the efforts evolve. »Our heads are round so our thoughts can change direction,« as Francis Picabia said.

Wim Pijbes
Former general director of the
Rijksmuseum, Amsterdam

My museum is a playground

Florian Illies
Best-selling author and partner at Villa Grisebach, Berlin

If you would like to know where the quality is hidden that will withstand the test of time, you should pay close attention to what the artists themselves are collecting. These will be the artists whose sincerity is held in high regard. The most exquisite collection of French Impressionism was not to be found in a museum but within Max Liebermann's home. And there is no difference nowadays. Artists are merciless in detecting the weakness of their kin, but, at the same time, also very reliable in recognizing where an old artistic problem has been solved anew.

Lorenzo Rudolf
Swiss art dealer, curator, founder
of Art Stage Singapore,
and former director of Art Basel

As a young and ambitious fair director appointed to Art Basel in 1991, I had a completely new vision for its future, shared by a handful of innovative exhibitors. Originally all international fairs were traditional trade shows, all organized along similar lines. We, however, wanted to create a global event. I had the final concept for the »new« Art Basel ready to be implemented in my drawer – a concept that has underpinned the success of Art Basel to this day – but was facing an insurmountable obstacle.

The entire process was supervised by an exhibitor committee who considered themselves to be experts in all matters, as well as also the ultimate authority concerning the fair's marketing and PR.

This committee was not at all keen to give up its unlimited power base and support

a radical change of direction. On the other hand, the managing director of the Basel fair corporation, the owner of Art Basel, and my employer, did not have the guts to dethrone the exhibitor committee and clear the way for the intended overhaul of the fair.

So I waited until mid-July, when practically all galleries were closed and gallerists – including my boss – were on holiday. I knew that his deputy had limited interest in the art fair. Confident that he would barely glance at them, I made him sign a stack of letters, among them, disregarded and duly signed off, an official letter from the Basel fair corporation which declared the exhibitor committee of Art Basel dissolved with immediate effect.

Some weeks later, committee members, refreshed and relaxed from their holidays, found their letters of dismissal in their just re-opened galleries. In the meantime, a small strategic committee was already busy working and actively supporting me in the repositioning of Art Basel.

The success story of Art Basel thus started with fresh ideas, and a little trick.

Rachel Donadio
European culture correspondent, The New York Times

Visit museums
on slow days.
Wear comfortable shoes.
Don't believe the hype.
Revisit your favorite works
of art to see
if they've changed,
or if you have.

Art needs the art world,
but after the party's over,
only the art lasts.
When in doubt, quote Goethe:

||

Art is long,

—

life
short,

—

judgment
difficult,

—

opportunity
transient.

||

<u>Allan Schwartzman</u>
Sotheby's Chairman, Global Fine Arts,
and founder of Art Agency, Partners,
New York

Even though we look to art for the
highest expressions of a culture, most
people attracted to art

–

be they
curators,
critics,
dealers,
collectors,
or even
artists

–

are more enthusiasts than originators.
Most follow the lead of others.
Vision is rare. As the number of partici-
pants in the field multiplies,
the amount of greatness does not.

Samson Young
Sound and multimedia artist, Hongkong

An artist must have a robust work
ethic. The most important thing is to
work, and to create and sustain the
circumstances that will allow one
to continue to work. Never wait for the
work. There is nothing more important.
To paraphrase Tchaikovsky in a
letter that he wrote to one of his bene-
factors: a self-respecting artist must
not fold her/his hands on the pre-
text that she/he is not in the mood, and
that is what separates the amateur
with great gifts from the professional.

Alain Servais
Investment banker and collector, Brussels

My favorite places to buy art are museums and biennials. Because of the privatization of culture, the public funding of art is decreasing sharply, leaving room for the private sector with galleries at the forefront. The untold deal is that galleries and their backers will fund a larger part of the production of the works necessary to the exhibition, and in exchange the institutions will lend their walls and their image for the promotion and sale of the works. What can be unhealthy is the lack of transparency in the process, wrapped up in a solid dose of hypocrisy. Provocatively, the museums and biennials could be better off with a commission on the sales.

They are my favorite places to collect because most often artists create their best works for museums and biennials, the cultural context is superb, and, curiously, often because of ignorance, there is less competition than on Art Basel's opening day.

Video art is one of the most important media of our time, but the art market does not have a clue how to sell it. Unfortunately it is stifling the media, depriving video of the necessary funding. The art market is trying to imitate other edited media like prints and photography without understanding that the value of a video artwork is not in a shiny box with a DVD and a USB key inside but in the distribution and exhibition rights attached to the works. Right now, the art market is selling wind to collectors in the form of a limited edition of support which can only be viewed legally in the collector's private circle when the artist keeps all exhibition and distribution rights.

This is why the prices are so low and the selling so marginal: nobody understands the medium and what they are now buying when paying thousands of dollars. Collectors will soon take that into their own hands and, in coordination with artists as well as savvy lawyers, define one model contract for the production, selling, and distribution of video artworks.

Martin Roth
Director of the Victoria and
Albert Museum, London

The collections in our care belong to you. We are merely the custodians. But we can only show a tiny percentage of them in our galleries and study rooms. What about all those hidden treasures that can be found carefully preserved in storage or that are too fragile to withstand movement and display? These are the real secrets of the art world, often untapped resources brimming with stories about design, culture and civilization. Our stores are the real museum; the museum is just one display window. We therefore need to change the rationale behind our storage and make it accessible. Wouldn't it be wonderful if we could harness the power of digital technology to create a central archive to give faster and more extensive access to the collections than ever before? The collections at our great museums and art institutions should not only belong to you in theory, but in practice as well.

SOME PEOPLE BELIEVE
ART IS A MATTER OF LI
FE AND DEATH, I AM VE
RY DISAPPOINTED
WITH THAT ATTITUDE.
I CAN ASSURE YOU IT
IS MUCH, MUCH
MORE IMPORTANT THAN
THAT. Kasper König
on art

Alexandra Munroe
Samsung Senior Curator, Asian Art
and Senior adviser, Global Arts, Solomon R.
Guggenheim Museum and Foundation

The secret to art is seeing, and artists are your best guides. Walk through the Met's Egyptian galleries, the Dunhuang caves, Matisse's chapel in Vence, or the Guggenheim with an artist friend, and listen to how they examine the art up close, following what they see. Sight is the most intelligent sense – and the most active one. Go in deeper.

Anita Zabludowicz
Art collector with a London-based
institution and with spaces in New York and
on an island in Finland

THERE ARE PEOPLE IN THE ART WORLD WHO ARE INSENSITIVE AND DO NOT WANT TO GIVE BACK. THERE IS A LACK OF SENSE OF RESPONSIBILITY TO ARTISTS AND INSTITUTIONS.

Olav Velthuis
Cultural writer and Professor of Sociology at the University of Amsterdam

All the talk about the current boom of the art market is grossly exaggerated. It is true that since 1990, the global art market has more than doubled. But over that period, the size of the world economy actually grew faster. In other words, relative to the world economy, the art market slightly shrank. Moreover, while the global art market doubled in size, the number of billionaires increased more than fivefold. So auction houses and powerhouse art dealers have not been that successful in seducing the newly rich to become art collectors. In the light of the enormous amount of wealth that has been created globally, the art market has been performing rather poorly.

Robert Wilson

US-American playwright, theater and visual artist, and founder and artistic director of the Watermill Foundation

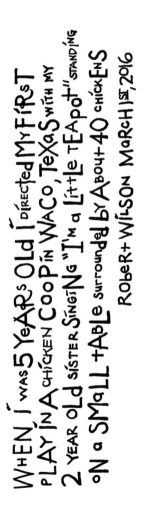

WHEN i was 5 YeARs OLd i directed MY FiRsT PLAY iN A chicken CooP iN WACo, TeXaS wiTH MY 2 YeAR OLd sisteR SingiNg "I'M a Little tEApoT" staNdiNg oN a SMaLL tAbLe surrounded bY About 40 chickENS ROBeRt WiLSON MaRcH 1st, 2016

Christine Macel
Chief curator at the Centre Pompidou, Paris, and director of the 57th Venice Biennial

In today's world, it seems as though everything is easy-access, yet many artists and their works are lacking visibility. And although nothing seems to get by the galleries, institutes, magazines, internet and other alternative networks, some artists and even entire branches of art are being left out, forgotten, basically going unnoticed even by more informed audiences. We are hyperconnected, over-informed – living with the illusion of knowing all there is to know. However, there exists something above and beyond this illusion that requires time, travel and research; something out of the reach of communication agencies that cannot land by magic in our inboxes. We do not know it all, far from it. Therein lies the pleasure of a ceaseless journey for new discoveries and falling in love with a new or re-emerging work of art.

<u>Matthias Mühling</u>
Director of Lenbachhaus, Munich

My grandmother was a
conceptual artist.
Wherever she spent her holidays,
for many years,
she always sent me a postcard
with the same line:

»Alles Scheiße, Deine Emma«
(»Everything sucks, Love Emma«.)

And Emma wasn't even
her name!

<u>Bernhard Maaz</u>
Director General, Bayerische Staatsgemäldesammlungen, Munich

It is better to see a single
work of art in any museum nearby
than trying to see many
museums in the world without
finding a personal favorite –
a painting or sculpture or
furniture or whatever. Permanent
collections and their local
visitors are the very future of
museums.

Do not forget
Goethe:
»Would you
roam forever
onward?
See the
good lies so
near.«

It seems like a German answer,
but it might be worth thinking about
for everyone and everywhere.

There is no such thing as a secret to success in the art world, just hard work. We live in post-heroic times.

<u>Koyo Kouoh</u>
**Founding director of
Raw Material Company, Dakar**

Hardly any African
language has a word for art
as a universal definition
of creative practice.
The different disciplines
and practices – which
do indeed have characteristic
words in all African
languages – often manifest
in combination,
and are defined as culture
rather than art.

Jeffrey Deitch
Art dealer, curator, and former director of the Museum of Contemporary Art, Los Angeles

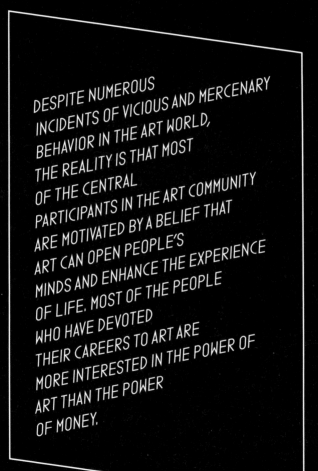

DESPITE NUMEROUS INCIDENTS OF VICIOUS AND MERCENARY BEHAVIOR IN THE ART WORLD, THE REALITY IS THAT MOST OF THE CENTRAL PARTICIPANTS IN THE ART COMMUNITY ARE MOTIVATED BY A BELIEF THAT ART CAN OPEN PEOPLE'S MINDS AND ENHANCE THE EXPERIENCE OF LIFE. MOST OF THE PEOPLE WHO HAVE DEVOTED THEIR CAREERS TO ART ARE MORE INTERESTED IN THE POWER OF ART THAN THE POWER OF MONEY.

Francis M. Naumann
Art historian and founding director
Francis M. Naumann Fine Art, New York

The best kept secret in the art world today has been hiding in plain sight for years:

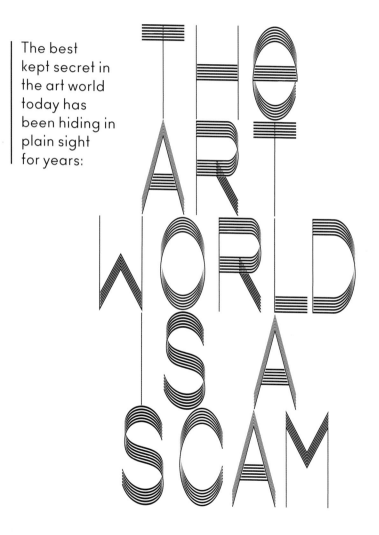

THE ART WORLD IS A SCAM

The system that allows certain artists to become famous and rich and woefully neglects others – in most cases, because they lack commercial viability – is an egregious injustice. It is an inevitable downside of an entrenched economic system that I – who began my career as an artist and now own a commercial gallery – regrettably end up perpetuating. Ironically, I feel just as victimized as the artists who go unrecognized, and who will likely remain unrecognized for the remaining years of their careers.

Nothing is wrong with the art they produce, nothing, at least, that even approximates the injustices of a system that repeatedly awards success and completely forgets about those who have never experienced it. We should remember that the artist Marcel Duchamp – who is recognized today for having introduced the concept of the readymade (an idea that radically altered our definition of art) – was not fighting against art history, or, for that matter, his fellow artists, as much as he was fighting a system that rewards some and ignores others.

Isabelle Graw
Publisher of Texte zur Kunst,
co-founder of the Institute for
Art Criticism, Frankfurt

It seems tempting to claim that there are no secrets left in the art world because this social universe increasingly targets the most intimate (and formerly secret) aspects of our lives. Indeed, our affects, our aesthetic preferences, the way we dress, and even our sexual relationships flow into our performance and are part of our product. What was formerly considered private is no longer hidden or protected – it gets staged, exposed, and commodified (as in social media) to an unprecedented degree.

While it is certainly true that the art world has always absorbed matters of life and is therefore a »bioeconomy« (Christian Marazzi) avant la lettre, the pressure to perform oneself has certainly increased due to the implementation of mass media in

the 1960s and even more so in the wake of digital networks. Today, many members of the art world thus frantically post pictures of their trips, encounters, exhibition visits, and lovers – there is no limit to their willingness to give their secrets away. However, not everything about them is known and on the table. What remains hidden is their fears: their fear of losing their social position, their fear of not succeeding, their fear of an unpredictable, insecure future and their fear that someone might discover that they are not that competent after all.

At times these fears become visible – as in the facial expressions of some of those members of the art world who regularly pose on gossip sites such as artforum.com. When looking carefully at these pictures, one can detect a latent fearfulness lurking through self-confident poses. But most of the time, they remain invisible and well hidden – the dark underside of an economy that wants us and our lives completely.

Zaha Hadid (1950-2016)
Iraqi-British Pritzker Prize-winning architect and artist

My »Big Bang« moment in architecture: the explosion was the decisive analogy and gesture that set off my creative career, breaking up the rigid order of all prior architecture, opening up the city block and injecting the fluidity and dynamism of contemporary life.

Study for the renovation of a London townhouse at 59 Eaton Place (ink drawing, 1981)

Max Hollein
Director of the Fine Arts Museums
of San Francisco

My secret of the
art world:
»that which has been
is that which will be,
and that which has
been done is that
which will be done. So
there is nothing new
under the sun.«

Ecclesiastes 1:9.

Princess Alia Al-Senussi
Art Basel representative, Middle East, and member of the board of trustees, ICA London

Connecting people is a lost art. We no longer have the old-fashioned salons reigned over by formidable doyennes, so we have to reimagine this for the twenty-first century instead.

Connecting isn't the same thing as networking and making true »junctions« is a pillar of the art world. Some say it can and will be done through social media;

I say it's through that same tried and true handshake and kiss.

After all, that's how the saying goes: you had me at hello.

Larry Gagosian
Gallerist, New York

I READ SOMEWHERE THAT ONE OF THE MOST IMPORTANT

ATTRIBUTES OF A SUCCESSFUL ART DEALER IS TO BE ABLE TO KEEP A SECRET.

Diana Widmaier Picasso
Art historian and granddaughter
of Pablo Picasso

I would like to deliver a family secret... My grandfather used a cotton with excrement produced by his daughter Maya (my mother), then aged three, to make an apple in a *Still Life*, dated 1938. According to him, excrement from an infant breast-fed by its mother had a unique texture and ochre color. Picasso had already told André Breton in 1933 that he wanted to use real dried excrement for one of his *Still Life* paintings, specifically those inimitable ones that he happened to notice in the countryside when children ate cherries without bothering to spit out their pits. The revulsion that this material might provoke is instead transformed into amazement as we grasp the full imagination of the artist. This work reminds us of the radical gesture he used in *Still Life with Chair Caning* dated 1912, which consists of the integration of a foreign body in a painting. At a conference in 2003 about stercoral matter, Jean Clair recounted an anecdote about Picasso: »There is a long history of shit in art. We say that when someone asked Picasso,

'Master, what would you do if you were in prison, with nothing?', he answered, 'I would paint with my shit'.«

It is indeed a way to give form to the formless. Excrement used as pigment is a pigment among others, without doubt a little more unusual, but with all its features: colorful as ochre, smooth as oil, a good covering power and relatively stable. Urine is also commonly used in the manufacture of certain colors or patina bronzes. Painters always had their recipes for making their own colors, until the invention of the paint tube. They could use a variety of materials like arsenic, minerals, resins, antlers, cuttlefish, dragon's blood and even snake excrement. In prehistoric times, we know that man used bird droppings to draw in caves. A mind so constantly and exclusively inspired is capable of poetizing anything, ennobling all. The gift of transforming the material into the dream and the fascination for organic life is what characterizes the genius of Picasso. For the artist, art and life are intimately linked, and this is what gives this *Still Life* all the tenderness that he felt for my mother Maya.

Calum Sutton
President and CEO of Sutton PR, London, New York, and Hong Kong

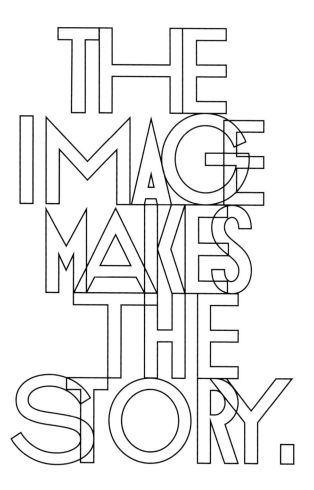

THE IMAGE MAKES THE STORY.

András Szántó
Art historian and consultant, New York

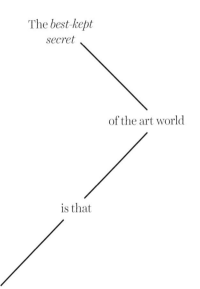

The *best-kept secret*

of the art world

is that

it no longer exists – at least in the original meaning of the term. For good or ill, the art world is now a cultural industry. Gone are the days when a small coterie of informed insiders, who more or less knew each other, more or less read the same books and magazines, saw the same exhibitions, and more or less lived in the same places in similar ways, sustained an ongoing conversation about which artists were good and bad, enveloping art in what Arthur Danto called »an atmosphere of theory«, which catalyzed consensus around commonly accepted values, and in turn, more or less informed prices and the choices made by collectors and museums. That was the art world.

Deyan Sudjic
Director of the Design Museum, London

For an insight into the often tortuous relationship between architects, artists, and curators, there is no better starting point than the early history of the Guggenheim Museum. Initially the choice of Hilla Rebay, Solomon Guggenheim's muse for the building, Frank Lloyd Wright was ruthless, overturning building code restrictions to build the museum that he wanted with the help of Robert Moses, New York's autocratic municipal power broker and a cousin by marriage. After Guggenheim's death, the trustees replaced Rebay – whose fearsome ego was matched only by Wright's own – with James Johnson Sweeney.

Rebay was incensed about Sweeney, a poet with a private income and a one-time collaborator of James Joyce, or, as Rebay put it, »a corset salesman who got himself fired by the Museum of Modern Art.« But it was as nothing to the friction between Sweeney and Wright.

Sweeney despaired of Wright's spiraling sloping walls as a place in which to show

serious art, while Wright ignored every attempt to discuss ways to make the building a little more fit for purpose. He accused Sweeney of a »malicious campaign to paint the museum white, thereby destroying its organic unity«; he attempted to have Sweeney fired, offering to find a well-connected replacement himself.

In the end, Sweeney had to wait until after Wright's death to devise a system of rods and cables to display flat rectangular canvasses on curved sloping walls. Even then, Robert Motherwell, Willem de Kooning, and nineteen other New York artists signed a petition questioning the Guggenheim's suitability as a setting for their work. »We shall be compelled to paint to suit Mr Wright's architecture,« claimed one signatory. The relationship between art, architecture and the museum can still seem to resemble the final three-way shoot-out from The Good, The Bad and The Ugly. Generally speaking, it's probably best if the curator and the architect get on, and that the architect knows something about art.

Susanne Gaensheimer
Director of the Museum für Moderne Kunst, Frankfurt

Art is just a moment,
a moment of sublimity.
The experience of
this moment should
not be confused
with its protagonists
and all our egomania
involved, otherwise
it's gone.

Isaac Julien
**Artist and filmmaker,
London**

TRY TO KEEP GOOD RELATIONSHIPS WITH YOUR COLLEAGUES, BUT STAY TRUE AND HONEST TO YOUR GOALS.

Aaron Richard Golub
Art attorney and
best-selling author, New York

There are no secrets in the art world. Everybody talks about everyone and everything and that is the art of the art world.

Bharti Kher
Artist and sculptor, New Delhi

The first thing about good art is that
it does what it's not supposed to do.
When you see something, you try
to feel it, and then you can go so
far as to imagine that you're
looking at something
that you can actually
taste and smell and
hear. So like the
snake, to see art
and to make art you
mustn't be human...
you have to leave the body
you know and smell with
your tongue, hear with your
flesh, taste with your eyes, try to
touch what you can't hear. Use your
nose to see what has been sent to you.

<u>Thomas Demand</u>
German photographer and sculptor, Los Angeles and Berlin

Every name in the artworld is
written with a pencil

David Galenson
Professor of Economics, University of Chicago, and director of the Center for Creativity Economics, Buenos Aires

The best-kept secret of the art world is that art markets are highly efficient and rational. Art insiders go to great lengths to deny this: for example, the critic Robert Hughes declared that art prices were due to »pure, irrational desire«, and Tobias Meyer, fomerly Sotheby's chief auctioneer, claimed that market valuation of art could only be described as »magical.« Robert Storr, former dean of Yale School of Art, furthermore asserted that artistic success is »completely unquantifiable.«

These claims are wrong. Quantitative analysis of auction prices reveals strong patterns. The highest prices are consistently paid for the works of the greatest artists – the same ones to whom scholars devote the most attention in their art history textbooks. And it is the most important works of these artists – those most frequently illustrated in the textbooks – that bring the very highest prices.

In art, as in all intellectual disciplines, innovation is the source of importance: the greatest artists are the most innovative, and their greatest works are those that introduce and embody their innovations. Some experts cynically deny this to protect the value of their expertise. Others, who have never studied economics or statistics, may be genuinely unable to perceive or comprehend these patterns. But one of the greatest innovators of the modern era knew better: Andy Warhol explained that »paintings are like stocks and a dealer is like a broker. Art is an investment.«

<u>Jitish Kallat</u>
Artist and artistic director of the second
Kochi-Muziris Biennial, Mumbai

TO MY MIND
MATTER OF
IS THAT
AND THE ART
NOT EXIST IN
FABRIC OF
THEY ONLY
GRAVITATIONAL
EACH

THE DARK
THE ARTWORLD
ARTWORKS
WORLD DO
THE SAME
SPACE-TIME.
EXERT
FORCES ON
OTHER.

Claire Hsu
**Co-founder and executive director of the
Asia Art Archive, Hong Kong**

There are *MULTIPLE* art worlds. Mostly they orbit in a regular, self-repeating pattern built on economic interests, shared languages, histories and geographies. At times, however, these worlds rub shoulders, caress, and even collide, and that's when it gets interesting.

Art is a form of knowledge and that knowledge has never been so accessible. You have the power to own it.

Sheena Wagstaff
Chairman for Modern and Contemporary Art,
The Metropolitan Museum of Art, New York

The word »secret« has become tarnished, used mainly in relation to conspiracy, power, skulduggery or intent to harm - yes, even in the art world! Yet at a time in which every second of one's life is recorded, conveyed, scrutinized or »shared«, it's good to keep the beauty of mystery alive. Great art can be profound, explicable, while its power and effect remain a conundrum. Keep the innocence of secrets sacrosanct.

George Condo
Artist, New York

1. I never watch The end of movies.
2. I used to only paint what I hated.
3. I invent woman I want to make love to.
4. Feb 2?, 2016

exclusively designed by George Condo for this publication

I'm playing
music
and I'm
guessing there's
a good reason

no one wants
to hear it.
Why? That's The
Secret

Feb. 20, 2016

Maria Baibakova
Art collector, philanthropist, and founder of Baibakov Art Projects

It's the worst-kept secret of the art world: women are still second-rate citizens. Don't be fooled by the attractive young women who greet you at the front desk of every gallery – women have a long way to go towards gender equality in the art world. In March 2014, The New York Times released a finding about the museum world that stated the following: »[Of the] *big institutions... with budgets over $15 million, only 24% are led by women, and they make 29% less than their male peers.*« For women artists, the situation is just as bad as for female museum professionals: while over 60% of art school graduates are women, a 2013 study conducted by Louisa Elderton of 134 London-based commercial galleries representing, collectively, 3,163 artists found that only 31% of the represented artists were women. Further, only 5% of these galleries represented an equal number of male and female artists, with 78% of the programs representing more men than women. So much for gender equality. The situation for female artists doesn't get much better when they enter museums. Only about 28% of monographic exhibitions across museums in the US focus on women artists. When it comes to collections, Frances Morris, the first female director of the Tate, says it best: »*If you take a snapshot of the women artists in Tate's collection after 1965, there's a similar [figure of] 30%, which is a massive improvement on the historical collections; 1900 – 65 is 19%, and if you look back prior to that, it's 1%.*« **The art world doesn't like to talk about it, but it's time to look truth in the face.**

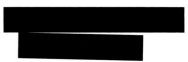

Juan Manuel Echavarría
Artist and photographer, Bogotá

Put seven artists in the same room for a few hours and see how those seven egos go at each other!

Juan Manuel Echavarría
Artist and photographer, Bogotá

Put seven artists in the same room for a few hours and see how those seven egos go at each other!

Jeff Koons
Artist and sculptor, New York

_____THE JOURNEY STARTS WITH SELF- THE SUBJECTIVE. ONCE YOU_____ YOU ARE TO THE WHICH IS

OF ART
ACCEPTANCE;

ACCEPT YOURSELF,
ABLE TO MOVE ON
THE OBJECTIVE,
HIGHEST STATE,
THE ACCEPTANCE
 OF OTHERS._____

Hans Ulrich Obrist
Director of the Serpentine Galleries, London

A SECRET ALWAYS HIDES ANOTHER SECRET
In the early 1970s, Icelandic artist Hreinn Fridfinnsson placed an advert in a Dutch art magazine asking people to send him their secrets. Forty years later, Fridfinnsson will conclude his »secrets project« for an exhibition at The Kunstverein in Amsterdam curated by Krist Gruijthuijsen.

Originally, Fridfinnsson's request for secrets had little response. This ephemeral and brief (non) event has nonetheless survived both in memory and as a rumor. In 2007, Fridfinnsson's advert was reprinted in Point D'Ironie, which produced new responses and secrets for the artist. In a discussion about the original printing of the advert, Fridfinnsson told me that »*if you acquire somebody else's secret, you must keep it as long as you live. You cannot pass it around, because then it is, of course, destroyed. That was the main point of the work: the very nature of a personal secret. That probably explains this absence of reactions.*«

The absence of reactions is only the surface of Fridfinnsson's project. Rather than an accumulation of personal knowledge, the project cultivates rumor and speculation; in essence, a much greater secret. Krist Gruijthuijsen, the organizer of the exhibition at Kunstverein, comments how *»by posing as a collector of secrets, the artist would, he thought, allay suspicions that he had any ulterior motive in using or revealing privileged information that might come his way.«*

Fridfinnsson once told me *»an archive I don't have. I just have memories.«* The process of collecting these memories, and their primacy over physical categorization and archiving, demonstrates Fridfinnsson's interest in using memory as a fluid, flexible material. This is evident in the exhibition at Kunstverein where the artist's collected secrets will form the base for a monochrome painting. Within this new context, content is superseded by the plastic form of the words themselves.

Over the forty years of patient silence and delayed artistic endeavor, Fridfinnsson engenders a public gaze and fabrication out of what is essentially an open system. A double archive is created: Fridfinnsson's archive of collected secrets and the immaterial memories of them, and the rumors that continue to surround the piece. Through hindsight, the project reveals the logic of its own internal disclosure: the secret might be that there isn't one.

Ingvild Goetz
Art collector, curator, and museum founder, Munich

I am truly concerned
whenever
famous artists are

REVERED

to such an extent
that an encounter
with their works
is devoid of critical opinion.
Sadly, time and again
that is the case
within the art world.

Chris Dercon
Former director of Tate Modern, London

Until recently, the art world
lived off of secrets.
Such was first and foremost
a matter of control of
information. Whoever
controlled the information
was kind of in power.
With the advent of so many
different »players« both
dilettante and professional,
and not least social media,
that era is now well over.
There are almost no secrets
left. Or better: they are
shared in a second.
What stays is the desire
to control and the hunger
for power – whether
symbolically or financially.

Hu Fang and Zhang Wei
Co-founders of Vitamin Creative Space,
Guangzhou and Beijing

In between the creases of time
Universe elongates in another form
As if bodies stretching
– you slightly turn your back
Beyond the deserted land
Surprisingly comes into sight an animalistic and lively land
It is almost a hidden garden under the cliff
The grace of labor
As if it had lit up the flaring firewood
And dispersed the misty mountain mist
Smoke rose up from the back of the mud wall
Awaiting
Our descendants
Our descendants could come from the circular track of time
And land their feet, once again,
On the muddy road

We still could not forecast
How long we need to walk
So that we can witness the tremendous origin
The clouds flow
Among the towering mountain peaks
The imminent coming of the night presents the melancholy
of this land

时间的褶皱处
世界以另一种方式延伸
犹如身体的屈伸
——你稍一转身
荒芜的世界背后
竟浮现出峰回路转的生灵之地
这几乎是悬崖底下的秘密花园
劳动的欣悦
就像驱散山地湿气的柴火
在泥墙背后升起
等待着
下一代
下一代有可能
从时间的环行跑道上
重新踏上泥泞的路面

我们仍然无法预料
步行多久
才能目击起源的战栗
而云层移动
山峰浮起
即将降临的夜幕更显大地的深沉
——摘自胡昉《形成》，来自胡昉和
张巍的回应

Cristina Ruiz
Editor-at-large, The Art Newspaper

——————————————— It is a truth universally acknowledged but never spoken: almost all art made and sold today will one day be worthless. Everyone involved in the contemporary art business knows that theirs is a game of smoke and mirrors; that the artists we laud today will most likely be forgotten tomorrow. History is a very harsh judge of talent. So buy the art of our time because you find it exciting, engaging, and moving. If you're hoping for a good investment, look elsewhere. ———————————————

Patrizia Sandretto Re Rebaudengo
Art collector and president of the Fondazione Sandretto Re Rebaudengo, Turin, Italy

I don't only choose artworks that mirror my personality: this is one of the secrets of my collection. Like many other collectors, originally I bought works that were close to my way of thinking, that felt somehow familiar to me. Since then the collection has grown bigger, becoming a world in its own right, a complex system of relationships. So I understood that, to keep it alive, I should take some risks towards the unknown. Thus, I learnt how to embrace the unfamiliar, the »uncanny« – works that can take me by surprise and leave me speechless.

Cao Fei
Chinese multimedia artist, Beijing

IV 恋人 — THE LOVERS

IX 正义 — JUSTICE

III 教皇 — THE POPE

VIII 命运之轮 — THE WHEEL OF FORTUNE

II 女祭司 — THE POPESS

VII 隐士 — THE HERMIT

I 魔术师 — THE MAGICIAN

VI 坚强 — STRENGTH

II 愚者 — THE FOOL

V 战车 — THE CHARIOT

Nicholas Logsdail
Director of Lisson Gallery, with spaces
in London, Milan, and New York

An art gallery
is one of the
nicest
secret places to
spend time
when you want
to escape
the weather
or just
be on your own.

Look with an open and thoughtful mind. A sense of yourself is given by your sense of place and where you are. Your perception of every-thing depends on this.

Mary Rozell
Global Head of the UBS
Art Collection

No matter how out-of-control the art market gets and how disen-franchised one feels with these unfathomable prices, there are still artists to discover and much joy and stimulation to be found. You just have to keep looking and learning

●

Hans Neuendorf
Founder of Art Cologne
and Artnet

Everyone wants to buy art of lasting impor-
tance. Museum quality is the watchword.
The good news now is that you may not
have to pay very much for it because,
if history is any indication, you will not
often find it among the most popular and
expensive artists.

»Art will never sell online,« is the general
wisdom today. »A speed of more than thirty
miles per hour is impossible to endure for
humans without imperiling their lives,«
was the general opinion at the introduc-
tion of the railway. »I don't need it,« said
many a dealer when Artnet introduced
the art price database.

Andrew Graham-Dixon
British art historian, author, and television broadcaster

I think of my favorite works of art as friends, of a kind. The other day I was discussing »Caravaggio's Calling« of St Matthew, in the Contarelli Chapel in San Luigi dei Francesi in Rome, with someone I love dearly. She is a painter, which perhaps enables her to see the stratagems of other painters with more clarity than most. In the painting, Christ has descended into the darkness of Matthew's worldly life as a tax-gatherer – the scene is set in the seventeenth-century basement office of a Roman tax collector – and is calling him to join his band of disciples. Matthew is being called to leave darkness, and enter light, and this is

communicated by the stream of light that illuminates the hand of Christ and floods in on Matthew in his den of thieves (or would-be tax-avoiders). But the painter's eye had seen shapes in Caravaggio's chiaroscuro that I had managed to miss. The light enters the room in the form of a wedge or a lever, angled like the arm of a set of scales that has been weighed down at one end. Matthew is seated at the base of this light-lever, in front of his coin-strewn table, which, seen thus, might be the heavy end of a set of scales – with him in it along with all the money he's been counting. His soul has been weighed down by the world, but now he will be raised up and made light – taken into the light. In other words, the whole picture is designed like the very mechanism that is one of Matthew the tax-gatherer's prime symbols, in traditional Christian iconography: a set of weighing scales, for counting gold. It seems such a blindingly clear expression of Caravaggio's original meaning: a perfect measuring up of what this great picture is all about. How on earth could I have missed something so obvious? I spent ten years writing his biography, I suspect I have read just about everything worth reading on the subject – and no one else seems to have noticed the weighing-scale structure of the picture before now, either. Maybe there's a bigger truth here anyway. Great pictures, like close friends, always have something new to teach us. There's no end to them.

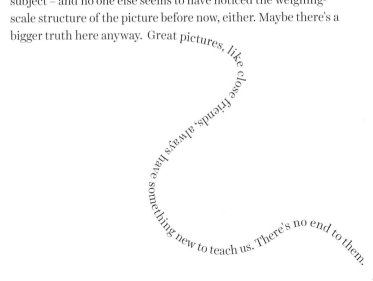

Editors:
Thomas Girst
Magnus Resch

Design and concept:
Studio Umlaut
www.studio-umlaut.com
Art Direction:
Christine Rampl
Daniela Wiesemann

Fonts:
Ano by alias, London
Harriet by okay type, Chicago

Copyediting:
Anne Cochrane

First published by Koenig Books,
London
Koenig Books Ltd
At the Serpentine Gallery
Kensington Gardens
London W2 3XA
www.koenigbooks.co.uk

Production:
Lösch Medienmanufaktur,
Waiblingen
Made in Europe

ISBN 978-3-86335-961-4

Distribution:

Distribution Germany,
Austria, Switzerland
Buchhandlung Walther König
Ehrenstr. 4, 50672 Köln
www.buchhandlung-
walther-koenig.de

Distribution outside the United
States and Canada, Germany,
Austria and Switzerland by
Thames & Hudson Ltd., London
181A High Holborn
London, WC1V 7QX,
United Kingdom
www.thamesandhudson.com

Distribution in the
United States and Canada
by ARTBOOK | D.A.P.
155 6th Avenue, 2nd Floor
USA-New York, NY 10013
www.artbook.com

The publisher made strenuous
efforts to establish the names
of all other copyright owners.
People and institutions who
could not be reached and wish
to claim the rights to images
are requested to contact the
publisher.